THE PERIPHERAL SPACE OF PHOTOGRAPHY

Murat Nemet-Nejat

The PERIPHERAL
SPACE *of Photography*

GREEN INTEGER
KØBENHAVN & LOS ANGELES
2003

GREEN INTEGER
Edited by Per Bregne
København/Los Angeles

Distributed in the United States by Consortium Book
Sales and Distribution, 1045 Westgate Drive, Suite 90
Saint Paul, Minnesota 55114-1065

(323) 857-1115 / http://www.greeninteger.com

First edition 2003
©2003 by Murat Nemet-Nejat

This book was published in collaboration with
The Contemporary Arts Educational Project, Inc,
a non-profit corporation, through a matching grant from the
National Endowment for the Arts, a federal agency.

NATIONAL
ENDOWMENT
FOR THE ARTS

Design: Per Bregne
Typography: Kim Silva
Photograph: Murat Nemet-Nejat

LIBRARY OF CONGRESS CATALOGING IN PUBLICATION DATA
Nemet-Nejat, Murat
The Peripheral Space of Photography
ISBN: 1-892295-90-3
p. cm — Green Integer 76
I. Title II. Series

Green Integer books are published for Douglas Messerli
Printed in the United States of America on acid-free paper.

I. An Illusion

I had been looking forward to the photography exhibit at the Met, "The Waking Dream," selected from the Gilman Paper Company Collection. This exhibit of the first hundred years of photography (1839-1939) contains 253 prints, occupies twelve rooms and covers three countries, England, France and the United States. Its initial effect on me was a vague sense of disappointment.

What excites me about the origins of a new medium, and aroused my expectations about the Met exhibit, is a glimpse into the relatively short period when the medium is nakedly conscious of its potential, what physical, scientific and historical factors brought it about, is unique about it, what is its nature and necessity. That is to say, a short moment before surrounding culture, outside values engulf it.

Besides the quote by Keats, "a waking dream," the first room contains the reflection on a cloth screen of the photograph of the back of a woman with décolleté shoulders, one of the photographs in the exhibition. This first room filled me with excite-

ment because in it I sensed a dramatization of what seeing a photographic image involves: seeing (itself a reflection) a reflection.

The second room, the beginning of the exhibition of the prints, is mostly devoted to the Englishman William Henry Fox Talbot. Talbot's main purpose, the catalogue write-up says, is to assert the legitimacy of photography as an art form. One might guess as much by looking at the photographs, two carpenters completely concentrated on the fixing of a farm equipment ("Carpenters and Apprentice, ca. 1844"), another group, the title says fruit sellers, the women in Dutch bonnets, looking intently at undefined objects in their middle ("The Fruit Sellers, ca. 1843"), etc. Each photograph reminds me, not only of painting, but of a specific or potential style of painting, for instance, Millet or second rate Dutch genre painting. The initial impact of the Talbot room is a sequence of déjà-vus. Here I have my first disappointment. My fantasy of seeing a new medium in a naked form, revealing its own language, is busted. The Talbot photographs are already overwhelmed by language; they are reproductions, not of a visual world, sup-

posedly pre-language, but of Victorian aesthetics of painting. Is the Met exhibit still-born?

"Art," in capital letters, huffs and puffs all through "The Waking Dream" exhibit. It reinforces the 20th century modernist prejudice: photography is art if only seen as art, a visual art invested with the aesthetic values of contemporaneous painting. This Talbotian prejudice distorts the photographs, either in the way they are framed or selected. For instance, why is Talbot the first major voice of photography? Were there no other practitioners who were less self-conscious of what they did?

My expectation to find, at the beginning of its creation, photographic language in its purest form, was partly an illusion. This exhibit is for me the story of a new medium to find its own language against the imposition of a given one. The signs of this new language, from its inception, are everywhere, and my pleasure is gleaning them out. By focusing on why I liked certain photographs and others dissatisfied or annoyed me, I realized that my pleasures had nothing to do, were inhibited, by the aesthetic principles imposed on them. In fact, the description of these experiences required a new

language, paralleling the new language of photography. This essay is an account of this discovery: I) the forces creating the photographic image are democratic. The photographic language lies in, is created by the conflict, the friction between the lens and these forces. 2) Photography is not really a visual/plastic medium associated, though different, from 19th century painting; it is a medium of reflection (reflection as image and as thought), intimately related to language. 3) photographic "seeing" is steeped in a Platonic epistemology—seeing reflected images on a cave requires a source, a numen.

II. What Is Democracy in Photography?

In the Talbot room there is one photograph, David Octavius Hill and Robert Adamson's "Cottage Door, 1843," which overwhelms me with its power. I look to see why. A few people are directly looking at the camera. Among all of Talbot's self-consciousness, where, as an "artist," Talbot tries to organize his people into sentimental 19th century paintings, here are eyes directly looking at the lens. Their glare from more than a hundred years ago overwhelms me. Here is the first originality of photography as a medium. The lens must always be acknowledged. While in painting, particularly in Talbot's painterly photographs, sincerity means "picturing" common people at their work, unaware of being photographed, in photography sincerity requires acknowledging, confronting, one way or another, the intrusive presence of the lens. A photograph is a dialogue between the viewer of the photograph and the subject being photographed. (This dialogue is non-existent in the modernist aesthetic of painting; it is between the viewer and the painter.) In essence every photograph has the same

dialectic, the same story to tell: the subject's (a person or a landscape or something else's) attempt to come to terms with the lens. This is the pose. There is a pose even in a city picture, in the picture of a sight. Photography is the medium in which the subject imposes itself (or himself/herself) into the dialogue of the photograph and refuses to remain an object, silent. This is its originality, its revolutionary nature. It is impossible to talk about, understand the experience of a photograph without understanding the subject's individual resolution to the camera. If photography is the democratic art, it is not because it is mechanically reproducible, as Walter Benjamin says (there is amazingly little mechanical in early photographic reproductions). It is because it gives speech to a previously silent multitude.

The irreducible distinction between contemporaneous painting and photography must be understood. In painting the dialogue is essentially between the painter (the artist as the manipulator of the medium) and the viewer. The subject is irrelevant, immaterial. In photography, the subject takes over the position of the "artist" in the dialogue. It

resists to be an object. In photography the photographer is pushed towards erasure, transparence because forced to share his/her position with the subject. Photographic subject can not be thematized.

The unique, revolutionary power of the lens, non-existent in any medium before the camera, is clearest in movies. At least conventional movies are empathetic and create their magic by weaving the illusion of a separate world. That's why movie actors can never look at the camera. The actor's direct gaze at the lens destroys all the illusion, pretense of naturalness. In TV news broadcasts, talk shows, etc., there is a sustained effort to pretend looking at the lens without doing so, to create the illusion of naturalness. The true function of a teleprompter is to avoid looking directly at the lens while pretending to do so. Only an outsider or a soap character can look at the lens, whereas looking at the lens is the original, integral act of photography. It is one of the three acts that separate photography from other media and define its own path.

III. Two Photographs of Denial

Rooms two to six of the exhibit are devoted to 19th century English and French photographs. Though subtle differences exist between them, they are both obsessed with the concept of photography as an art form, as painting. French photographs are much more infused with light, partly due, I think, to the difference in climate since the medium of sand paper, through which most of them were taken, requires a very long time of exposure. But in most of these there is still the monotonous attempt to frame the scene, to make it "aesthetically" balanced. Nowhere is my dissatisfaction more crystallized than two quite different photographs. One, byTalbot, "A Scene in a Library, 1843-44," is a close up photograph of a bookshelf with rows of books. The attempt is to create the effect of a 17th century Dutch genre painting. In fact, the photograph has the dark hues (isn't a good deal of it grime?) associated with such paintings. The write-up to the photograph says that this photograph, like many others, was taken outdoors because indoors would never have sufficient light. The monstrosities an

"artist" can put a medium through to satisfy a pre-existing concept of legitimacy, of beauty, of art. Here the subject, a shelf of books, under the concept of art, has been silenced, denied speech, kicked out of the photographic discourse.

The other is a 19th century French photograph by Édouard-Denis Baldus, "Lyons During the Floods of 1856," taken from the top of a building. The write-up explains that the city was overrun by floods, and the photographer was sent by the state to take the picture of the devastation to make an argument for help. By the time of his arrival the flood had half receded. What is striking about the photograph is its serenity, its balance. I could not tell it is the picture of a flood. The white planes of the buildings are interspersed with the flooded areas very much like a French garden. The photograph has the "aesthetic balance," frame, elegance, even the hue, light, of academic French painting. I am sure that is why the curator included it in the exhibition as an example of 19th century photographic "art." Here again, the subject of the photograph, Lyons, is erased from the photographic experience (pose is not confined to people; it permeates the w-

hole photographic space, every object in it). While I can approach Talbot's Procrustean bed, monstrosity of alfresco bookshelves with humor, as a delicious example of camp, the good taste, elegance of Baldus's photograph makes me slightly nauseous.

IV. Em. Pec.

There are wonderful photographs, and another pursuit independent from the pursuit of "art," among the underlying monotony of these 19th century English and French photographs. Two are by someone with the signature, Em. Pec., themselves worth the visit to the exhibition. The first is "Chartres, 1850-52," the photo of part of the wall of the Chartres Cathedral, not from a vantage point, but the point of view of a pedestrian, a tourist. The size of the wall overwhelms the picture frame and bursts into its corners. Black and white shadows, caused by the idiosyncratic undulations of the Medieval wall, cut across statues, which seem to fly in the air. The space in this photograph is not rational, framed; but private, suggests the chaotic process of seeing, a dialogue between the eye and the subject, the irregular Medieval wall.

The second, "Bourges, 1850-52," shows four old men (does the title refer to the Cathedral or the four bourgeois?), with canes, sitting on a bench with a heart-like motif standing exactly above the head of each. The eerie precision of this positioning

is assaulted (more than contrasted) by the fate of the faces. One of them is a black space, the other is blurred, the third so shadowed almost invisible, the fourth is empty space, light, a decapitated whiteness. The effect is a terrifying joke as though one is looking at a photograph of dying. The viewer is never sure if the balance of the hearts over the heads is accidental or intentional or the wipe outs themselves intentional or the result of something having gone wrong, the insufficiency of the photographer, a mistake, a blur out, while transferring the negative copies of the original figures onto the positive images on the salt paper. Intentional or not, the power of this photograph has nothing to do with painting but is integral to the nature and limitations of photographic medium itself, involving not copying, but the "perilous and ambiguous process of reproduction" and the demands the photographic subject puts on the lens. Did at least one of them move? The power of the experience partly derives from the insufficiency of the medium, the photographer's failure, as a "perfect" medium of reproduction, the light from the old men traveling its circuitous route of negatives and positives onto the

salt paper. The process is a "failure" beyond "intentions." The "blurs" replacing the faces contain the authenticity of photography as a medium and an experience. In true photography the subject in front of the lens tends to overwhelm the photographic medium, photographic space and photographic frame. The light emanating from a photographic subject is, while the producer of image, chaotic. The relationship between light and photographic medium (capturer of light) is unstable. The second leg of the photographic language lies in the process of reproduction through the transfer of light. The power and originality of photography as a medium lie in this instability.

Therefore, pose—independence of photographic subject—and reflected light—its resistance to reproduce the perfect image—are two legs of photographic language.

v. The Democratic Pose/ Space
in Gustave Le Gray

Gustave Le Gray's "Group near the Mill at Petit-Mourmelon, 1857" is one of the most exciting pictures in the exhibition. The stunning tension of this photograph has to do with questions it asks about posing. The picture is infused with the uncertainty of how to pose, the different subjects' not knowing how to present themselves before the lens. A group on the right, mostly dressed in home-spun black, mostly male, are looking straight at the lens, mugging in front of the camera. In fact, two men, like odalisks, their arms holding their heads, are reclined in front of the group. The group is a wonderful chaos of poses, as if, for this group, the language of how to present oneself in front of a camera is not yet invented, and everyone is trying to find his or her own.

On the left there is another group of lean, smartly dressed people, shaded in white-gray. In profile, their hands in their pockets, they have the sophisticated, "déshabillé," "artistic" look of the upper class, the Talbot look of the "painterly," who already assume, "as artists," they know the lan-

guage of the photograph: ignoring the camera. The focus of the lens is not on either of the groups but on a wedge exactly in between. This choice completely neutralizes the camera as a taker of sides, but lets each side, each poser speak for itself. The pose is the language the subject (human or not) chooses to create the dialogue with the viewer, instead of the photographer. On the right of the photograph there is a pastoral landscape (a pond, trees); but that pond (and the trees surrounding it) is an "intrusion" in the photograph, the way kids wave their hands at the peripheries in the evening news. There is a claustrophobia in this photograph's space; the space is bursting at the seams, at the frame because there is an excess of language (that of Barbizon landscape of the right, of the dark-hued group in the middle and the light hued-group in the left) clamoring for recognition. The tension in the photograph is the lack of balance, recognition among these three voices. The lens takes no side. The photographic frame is destroyed because each subject asserts its claim. The photograph is about different subjects' struggle for recognition. Balance is replaced by excess.

The pond on the right, the trees, are part of the struggle. Will they be subsumed to the symmetries of the old order, like Baldus's photograph, or elbow themselves a new place. This photograph reminds me of a shove into the New York subway during the rush hour.

The write-up says that the photograph is an outcome of a pose between the villagers and the upper echelon intruders. "Here, perhaps on a Sunday afternoon, a few officers and their wives have shed military discipline for a relaxed encounter with the local populace of Petit-Mourmelon." (p.289) The encounter is anything but relaxed. The photograph lets the tensions speak for themselves by letting each group enunciate its own language as pose.

Undermining the language of power, of authority, as "pose," "convention," seems to be the meaning of Gustave Le Gray as a photographer. In his work one sees pose not as a conventional gesture, but as a way for the "unnoticed," unheard subject to assert itself. He sees this medium in a completely new way, anti-painterly. His photographic space is not an aesthetic field where beauty can express itself, but a social field where new democratic forces

can take over. His space is subversive.

Take his photograph of military maneuvers, "Cavalry Maneuvers, Camp de Chalons, 1857." The delicate balance between the cavalry on the right and the scattered horsemen on the left appears to have the minimalist elegance, balance of an "object of beauty" like Maldus's photography of the flood. Except here the ground seems to tilt downwards as it moves right. The effect is undermining the whole concept of elegance (and the photograph's official function) the shot seems to celebrate. The elegance is out of balance the way in the other photograph the poses are in excess.

His "Mediterranean Sea at Sète," once again, is a rewriting of the language, "pose," of the sunset as a value of "balance." In the given language of sunset, the lens makes a choice of focus between the sky and the sea. One is focused, and the other "shaded." Le Gray "democratizes" this process. In this seascape two photographs, one of which focused on the sky and the other on the sea, are joined. The result is a seascape, a horizon, where the sea and sky are joined with equal focus. The process, which parallels the focus on the white

wedge between two groups in the Petit-Mourmelon photograph, has two consequences. The double gaze neutralizes the photographer's focus by eliminating choice (a double focus is the same as no focus). The second, this "trompe l'oeil" introduces, once again, the element of excess, as opposed to balance. The effect is that of a denied voice (shaded, either sky or sea) asserting, elbowing itself into the dialogue. Hierarchy, balance (traditional concepts of art) are replaced by equality, excess, a completely new arrangement.

What is this new art, what is Gustave Gray's post-modern modernity? A photograph ceases to be an object, particularly an object of art, with a clear, consciously defined frame; it becomes a piece of paper (feeling like soft cardboard), with no clear edges, a continuum, through which social forces and light and shadow act themselves out. Photography basically is not a plastic (or even visual?) but contemplative art, intimately related to language, turns to language. In movies, where images turn to movements, words are inside the frame. In photography words are attached to it, are propagated by it. That is the reason for the compulsive need to add

write-ups, captions. In movies the instinct of images is to turn to movements; in photography the instinct of images is to turn into words, contemplations about time, mortality, eroticism, silence, social change, etc. Photography is based on an essential pun on the word reflection: reflection as reflection of light and reflection as meditation. The first elicits the other. The visual experience of a photograph is not plastic, defined by the aesthetic frame of the object, but inescapably moves away from the object, from its central focus. For instance, before everything else, a photograph is an epitaph, a thought very rarely on the photographer's mind. As I already mentioned, the photographic experience resides in the dialogue (in language) between who or what is in front of the lens, in the process of defining itself through "poses," unconcerned with its mortality, and the observer, contemplator of the photograph. The photographer is an intrusion. This thought has important consequences.

The prevalent, orthodox assumption is that what elevates a photograph to the level of art is the focus, the frame the photographer chooses from which to "see" the event. In this approach "frame," the pho-

tographer's, is the backbone of value. This is the opposite of what happens. What is most relevant in a photograph is not what the photographer focuses on, but what he or she ignores. In the case of a self-conscious artist like Le Gray, this "ignorance" may be intentional (by the lens focusing on a "white" wedge or refusing to make a choice, "Petit Mourmelon" and "Seascape") or it may be, as in the case of a lot of stirring photography in the world, including amateur photography, accidental. Either way, the center of power of the photograph moves away from its "focus" to its peripheries. The most powerful space in a photograph resides in its peripheral space and the blank space, the glow, extending around, beyond the frame. This is the space of accidents, "failures," social movement, contemplation. It is in the peripheral space that image turns into language, the dialogue between the subject and the observer of the picture occurs and the "frame" of the photograph is demolished. It is the presence of peripheral space that turns the photograph from an "art object," de-emotionalizing that concept, into a "medium," a piece of paper of "reflection," as light and as meditation. This pun

contains the essence of photography. Photography explores the relationship between light and society, "words." Words, like pearls in an oyster, are the consequence of sickness, friction, imperfection, the failure of light to create a perfect image. Photography is a double reflection, not a copy or reproduction. The process of reflection is always imperfect, slanted because it involves a change of medium. If, spatially, the peripheries of a photograph collect its emotional power, linguistically, images turn into words when the process of reflection from photographic subject to object is impure, the reflective progression of light is somewhat thwarted.

Here we have the reversal of the assumed aesthetic and linguistic hierarchy: the "focus" of the photographer is replaced, by being "neutralized," by what it "ignores," by the "gaze" of the subject. This reversal liberates the photographic space and pushes it into the peripheries. It replaces the link between photography and balance (visual/plastic art of painting) with the link between photography and language by eliminating the photographer and creating a dialogue between the subject and the observer. It establishes the pun on "reflection" in the

photographic language.

Here I would like to point out one of the most frustrating aspects of the Met exhibit; I begin to realize its baffling impact on me despite the great number of interesting photographs. Except for the ones which appear in books or broadsides, all the photographs in the exhibit are carefully, obsessively framed. In fact, they give the impression of being cropped though they may not be so. Unless in a book, no photograph is given the "empty" space around itself to breathe. The exhibition, by aggressively framing each photograph by a white cardboard, focuses compulsively on the photographer's focus. The implicit aesthetic in the exhibition is that what makes photography an "art" is the photographer's choice of "frame." The exhibition is saying repeatedly, "look at this work of art, look at the individual choice the photograph makes in this shot, look at 'Art' with a capital letter."

To me the power of many pictures in the exhibition derive from their environment when that environment is permitted to stand. For instance, Henry Rhorer's "View of Cincinnati, 1865-66" is displayed as a foldout flyer attached to the middle of a

book on Cincinnati. The wonderful pathos of this photograph derives, for me, from the folding creases in the photograph as though the paper could not sustain all the material, the vista it has to include. Half of a bridge zooms at the lens, and the city of Cincinnati, in the process of its expansion, extends on both sides of the bridge. The write-up to the picture reveals a surprising fact. This is not one picture, but four. Those were not folding creases but the places where the four are attached together. In Henry Rohrer's picture we have something similar to Le Gray's "Seascape" where the sky and sea are equally focused. The photographic subject, in Rhorer's case Cincinnati, asserts itself and overwhelms the photographic focus, frame. "View of Cincinnati, 1865-66" is a clear example of the "pose" of an inanimate object. If this photograph were taken out of the book and flattened and framed like most of the other pictures, this intrusion of the photographic subject into the frame, the tension between the photographic focus and the focus of the photographic subject would have been lost. The original surrounding "eliminates" the photographer and makes "View of Cincinnati" a di-

alogue between the viewer and the expansive assertion of the photographic subject. "View of Cincinnati, 1865-66" is about Cincinnati, its manic growth, in a way that Baldus's "Lyons During the Floods of 1856" is not about Lyons, its flood. Baldus's work is more a pseudo academic painting, of Versailles, than a photograph.

The wonderful pathos of John Dillwyn Llewelyn's oval "Thereza, ca. 1853" is there because it is in a book: a woman looking through a microscope. The tension between the "masculinity" of that pursuit and the "femininity" of the flowers surrounding the oval image is made apparent because they both stand in an open space, surrounded by the leisurely space of the page. It turns this affectionate, loving photograph into the "unconscious," "accidental" gesture of a document: a piece of Victorian paradox, a comment on love and time and society.

VI. 19th Century Light

"Light," the light "reproduced," the "white," in a 19th century photograph is like nothing else. It does not appear like a "reflection" but a "glow," the feeling that the light has been trapped in and is directly emanating, not reflected, from the photographic material. Light in 19th century photographs is spiritual because it is not transparent, but "impure." It permeates like an "aura" the "white" spaces, the negatives turned into positives, of the photographs. Like birthmarks of kinship, yes, even nobility, photographs of completely different characters share it; William Marsh's "Abraham Lincoln, 1860" has it, Henri-Victor Regnault's "Gardens of Saint-Cloud" has it, John Murray's "The Taj Mahal from the Bank of the River, Agra, 1858" has it, Robert Macpherson's "The Theater of Marcellus, from the Piazza Montanara, 1858" has it, the white of the buildings in Eduard-Denis Baldus's "Lyons During the Floods of 1856" has it, etc., etc., etc.

This "glow," opacity has nothing to do with the photographer's intentions. In fact, 19th century photography can be seen as a constant struggle in

technique to make the photographic image "transparent," from paper negatives to glass negatives, from salted paper prints to albumen silver prints, etc. The glow is the result of the medium's "failure" to achieve perfect transparency. This "failure" materializes the light, makes it something inherent in the material, emanating from it. This "blurring" is not intentional, but exists at the very edge of technique.

Certain photographers, sensing this quality of the photographic light of their time, tried to retain, "accent" it. For instance, in his early period, Gustave Le Gray tried to develop a technique using waxed paper negative in order to blur details into light blocks to create "artistic," painterly, Barbizon effects. But these attempts are irrelevant. Le Gray's radical work occurred later, using glass negatives, when he revolutionized "the pose," the photographic space and framing. In these later photographs the light (glow, white) is used ironically, as the sky in "Cavalry Maneuvers, Camp de Chalons" or in the trompe-l'oeil of "Mediterranean Sea at Sète." In "Group near the Mill at Petit-Mourmelon," the white light is at the core of the photograph,

the heart of the camera's focus. (If there is one painter of the time that photography reminds me of is Manet. Picking on Velasquez, Manet uses the photographic stare in his work. His paintings are photographic, snapshots in oil. That's where their power lies.)

The white glow of the 19th century photographs has nothing to do with painterly effects (the reverse is true) or Romantic medievalism. It is an integral part of the history of "transparency" (and its relation to reproduction, reflection). This white glow, the opacity of clarity, is the result of the dialectic between light and the medium to reproduce it. It is the sign of the insufficiency of the medium. This insufficiency defines it. The glow is a combination of lack and excess, lack because the reflection from the medium (the negative) is not perfect, and excess, the excess of light, glow, trapped in, emanating from the print. These photographs all seem, to my 20th century eyes, even the most technically accomplished, slightly or on the verge of being overexposed. This excess is their constant source of power: a light the medium can not completely hold or integrate, in excess of the medium. This oxy-

moron has other ramifications: a blurring, a failure creating an excess of sadness, turning the photographic object, a piece of paper, like a bottle, holding the light of a hundred years ago, into an object of meditation on time, on mortality, the sadness of light surviving the object from which it emanated, the image, in this production of excess, turning, spilling into language.

In all ways photography is the medium of edges: edge of frame, turning images into words; edge of technique, turning reflected light into glow.

VII. Words In A Photograph

Words in an old photograph, for instance, a sign giving the name of a street already altered, are infinitely thrilling to me. Why? Because the experience of looking at a photograph always involves language, words, beyond the image, and the experience of seeing words in a photograph makes the looker feel that the photograph has come alive and is directly speaking to him or her.

VIII. The Synthesis of Light and Pose: the New Photographic Language

Nowhere is the intrinsic relationship between light and posing more apparent than in two American photographs, near each other, William Marsh's "Abraham Lincoln, 1860" and the anonymous photograph of a written flyer, "Broadside for Capture of Booth, Surratt, and Herold, April 20, 1865 (sic)."

The first striking thing about Lincoln's photograph, taken after his first nomination for president, is that he is unbearded, and the light, a glow, emanates from the bare face and the shirt. The absence of the beard and the "excessive" light around the face and further down has the uncanny effect that one is looking into Lincoln's soul, under the public image. Other details reinforce this impression, the disheveled hair, the Mona Lisa eyes, the wrinkling suit over the extremely thin scarecrow of a body, and those wonderful, extremely bony hands, one over the other, the same light as the face emanating from them, a perfect image of composure, self-containment. Unbearded indeed. Lincoln, the public figure, in his presidential nomination, choosing, perhaps instinctively, a pose of extreme

privacy, self containment (why choose otherwise that position for the hands) to define himself.

Then we look at the photograph of the broadside on the next wall. I am struck by the conventionality, "ordinariness" of the three murderers' poses. Surrat, well coiffed and straight up, in a top coat similar to Lincoln's, is standing with his hand on a draped coffee table; Booth, sitting, a cane between his legs, not looking at the camera, his arms bulging out, in a pose of the second rate actor that he is; Harold, carefully dressed, standing up, with one hand on a book on a table, looks like an accountant. Suddenly, I realize, these "radicals," murderers, destroyers of the social order are in effect the essence of the conventional ethos, that the assassination was in effect an expression, outburst of conventional minds.

(This is the first paradox of the Lincoln and the broadside photographs. The photograph of the "public" figure is the picture of the private self, and the photograph of the anti-social people becomes the picture of the conventional mind.)

This anonymous "Broadside" has other surprises. One suddenly realizes that the picture of each

assassin is framed by a black band. Why, are the assassins being mourned? Are they the victims? The pictures of the assassins occupy a relatively small portion at the top, less than a third of the photograph. The rest, the majority of the photograph, is taken by black writing characters of different sizes announcing that "the murderer of our late beloved President, Abraham Lincoln, is still at large" and offering a $100,000.00 reward for it. Nevertheless, the characters referring to "our late beloved President" are much smaller, inconspicuous, almost an interpolation, in the prominence of the act of murder. The response to this photograph is much more ambiguous, less clear than the words imply. It implies a disturbing doubleness to Lincoln's murder, reflecting, perhaps, America's ambivalence towards the event at the time. A disturbing glow of light permeates the background of this black writing. In fact, on one level, for me, it turns this broadside of murder "of our late President" into a secret black mass.

The "writing" aspect of this photograph has further points of interest. I notice that if one removes "of our late beloved President, Abraham Lincoln,"

which is squeezed in smaller and thinner characters between the other lines, one has: "The Murderer//Is Still At Large//$50,000 Reward" (The $100,000 strangely devalued to $50,000). A pure sensational headline in a newspaper. The photograph is the picture of a rag headline pretending to be a broadside at the service of catching the murderer of a beloved figure. It is filled with the thrill, excitement of murder. It is this thrill that the photograph, "Broadside," catches, and America's ambivalence, as a racial society, towards Lincoln's murder.

Another thing about this photograph is that it has no frames. The writing starts from and bursts into the peripheries. The frame of this photograph is inside the photograph, around the three assassins. The final mystery of this photograph derives from the fact that it is a picture, almost an X-ray picture, of photographic experience, not photography as an aesthetic, frameable object, but a medium of democratic meditation where image spills into language.

"Broadside" is the image of photographic language. If the inherent power of photography lies in

its peripheral space, then "Broadside" is a photograph of the heart of photographic space. Images are turned into their essence of self-defined poses and merge with a field of words surrounding it, which explode beyond a non-existent frame.

IX. Magical Messages from the American Studio

Light and Pose, the focal points of photography. A tension permeates 19th century American photographs between pose as something imposed by the photographer on the subject and pose as something asserted, defined by the subject. This tension makes a sequence of studio portraits evocative, thrilling, overwhelmingly powerful.

The first one is the anonymous daguerreotype, "Hutchinson Family Singers, 1845," which reminds me vaguely of Gustave Le Gray's "Group at Petit-Mourmelon." Looking at it with late 20th century eyes, one has the sense of a drag show. Ten men, sitting, a few of them standing up on the left, in front of the camera. The ones on the left and the right have their cheeks resting on the shoulders of the ones next to them. Most of them holding hands. One standing up on the left has bent and his cheek is touching the hair of the man sitting in front, and his hand is gently holding the temple of the sitting man's head. Most are looking at the camera, a few are looking away. In their nineteenth century clothing, all in soft leathered boots, at least three of them

have their hair parted in the middle, slightly disheveled. What is this! An expression of brotherly love? Of happiness of working together? Of non-Puritan, pre-lapsarian innocence? An assertion of Bohemian life?

The arrangement of the sitters forms an arc, partly achieved by the sitters on the periphery putting their heads on the shoulders of those next to them. Even the cheek touching the hair has this purpose of smoothing the arc. On what basis are these figures arranged? By height, by age, by their importance in the singing group or family or on the principle that those whose hair is long and parted on the side (the poetic De Musset look) must sit on the sides and rest their heads on the shoulders of the other guys, more masculine looking, and clasp their hands? The photograph bursts with gentleness, humor, a mysterious, sweet, unnamed kind of bond, partly due to the eyes and the smiles of several which are strikingly similar.

Then, I read the catalogue write-up to the photograph, which sees it as a "near perfect, graphic expression of musical harmony. The physical likeness and attitude of the sitters in the composition

produce a unity of effect, a consonance, much like a tuneful song." (p.309) Is that all there is? A metaphor for their job? Nowhere is the distorting, ridiculous effect of conceiving photography as an art work "framed" by the photographer more obvious.

The pose, the gestures in this photograph are defined by the subject. Their meaning is essentially undefinable, going beyond anything imposed by an outsider. The pose is a photographic dimension which goes beyond the intention of the photographer and suggests the independence, asserts even the very existence, of the subject. The pose is the key to catch the independent, socially ignored, unsaid, unacknowledged in the photographic act.

Another American photograph is Mathew B. Brady's "Portrait of a Man, ca. 1857." It is a formal studio photograph of a dignified, well-to-do man, in formal black clothing, well-coiffed, wearing glasses, standing up, looking at a point to the right of the camera. So far, so good, a conventional, well-executed photograph. The key to this photograph is the mahogany, curved Victorian chair to the right of the photograph, obviously a prop for

the subject to put his arm on. The subject does not do so, but hooks his arm and holds the lapel of his coat. This is the subject's independent gesture, going against the expected pose of the photographer. This gesture is the core act that gives the elegant self-assurance of the subject steel, heart, strength. One might say that holding the lapel is another conventional pose. But not in the presence of the chair. Imagine the picture with the man's hand on the chair. The figure of the man turns into a mish-mash.

One question haunts me at this point. Is this effect intentional on Brady's part? Did he place the chair in this shot and then ask the man to hold his lapel? This is possible since the straight vertical other arm of the man seems to parallel the vertical motion of the chair. Even if so, this is irrelevant. Brady's posing, his arrangement, is at the service of liberating the subject from his or her environment. Brady's focus is, in terms of social, established values, neutral (even though he kowtowed to the rich). In no way does he frame his subject but lets the subject speak in his or her language, this resulting in unexpected, explosive, often subversive, ef-

fects. Brady is the first photographer who sees photography as a democratic, practical, rather than an artistic medium.

Brady is the first portrait photographer completely free of painterly effects or even concerns. Painterly poses, light and dark effects, frames are replaced by studio props and by the subjects' relationships to them, to this 19th century furniture. Anybody rich enough to pay his fee (Brady's democracy is upper middle class) is king or queen for the day, and the photographer is at his or her service to see the subject as the subject sees himself or herself. This withdrawal of the photographer as an "artist," his commercial modesty, liberate photography as a medium and make it a medium of unexpected revelations, both by the subject and beyond the subject's or photographer's intentions. Brady's Victorian furniture props, seemingly celebrating middle class values, have an explosive dimension created by Brady's essentially neutral focus.

Brady's "Senator and Mrs. James Henry Lane, 1861-66" is a good example of the essential nature of photography as a reflector, in terms of pose, fur-

niture and light and dark, of social ethos. The focus of the lens encompasses two figures, Mr. and Mrs. Lane, equally. Senator Lane is standing on the right. He is a superfluous collection of self-defining theatrical gestures: black coat and suit, unruly hair, one hand in the trouser pocket, the other hand on the chair, careless, unraveled neck-tie, high forehead, the light falling on it, deep-set eyes, bony head, a perfect pose of the romantic rebel, the intellectual, no nonsense political rebel, except for that hand resting on the back of the chair. The observer's first focus is on the man, in his black suit and full of masculine assertion. The senator is a collection of right-minded, conventional gestures, no doubt as a politician mostly chosen by him, of strength, masculinity, power. His serious gaze to the left of the lens, suggesting the seriousness of his mind, of his vision. Here we have an "excessive" self-definition, chosen by the subject himself, of a rebel in a language of conventionality.

Then we have the wife, sitting in this rich taffeta dress, making a perfect heart, the face itself making a perfect oval, meek, petite, oppressed, and these eyes, gazing straight at the lens. If these eyes could

speak, these tight lips could speak, they would be Emily Dickinson. Mrs. Lane's stare contains, in contrast to the restrictive prettiness of the clothing, the unacknowledged voice of American woman. It is the most powerful stare in the exhibition, full of pathos, yearning, bitter tight lips, as if behind a prison wall.

The photographic glow of light falls only on Senator Lane's super wide forehead (man as brain); but it falls on Mrs. Lane's complete face, surrounded by a halo of lace, a dried-up Mary Pickford, wearing clothing which dwarfs her, spiritualizes this face.

Brady's photograph is an intricate web, surface of conventional gestures, objects, exploding, breaking, cracking into an unexpected, unarranged communication, becoming the language of the ignored, unacknowledged. It is a perfect example of photography as a medium of transparency, where an extreme "faithfulness" to, involvement with conventions end up with breaking these conventions apart, showing their insufficiency, the instabilities in their transparency.

Why are the Victorian props, the heavy drape,

the Gothic coffee table, the box (Pandora's?) on the left of this photograph? The obvious answer is to associate Mrs. Lane, who is also sitting on the left, with domestic virtues, activities, housekeeping, knitting, etc. But, on a subliminal level its impact is very different, its opposite. It extends the space belonging to Mrs. Lane and makes it the equal of Mr. Lane's. Objects of adaptation and domesticity, curtains, coffee tables, knitting boxes, because of her gaze into the camera, become objects of assertion and self-definition.

That direct stare may be the only unintended, independent gesture by one of the subjects in the photograph. But it transforms the picture, makes Mrs. Lane, and her unworded, uncodified, unacknowledged point of view, the focus. It brings the woman's point of view, that of a second class citizen, into consciousness. It finds a language for it. Here is the revolutionary aspect of the pose (gaze) as an independent gesture of assertion of the unnamed.

I think one has to elaborate on the meaning of gaze, a choice to look into the lens, as an integral part of the photographic experience. A pose is not a

"candid" shot. The subject knows he or she is in front of the lens and looking or not looking at it is a matter of choice. Maybe due to the early association of photography with painting, not looking at the lens is the "conventional," "educated" choice, in conflict with looking. Earlier, I mentioned Lincoln's Mona Lisa look in his photograph. What I mean by this is that Lincoln is slightly cross-eyed in it. While one eye is looking at the camera, the other looking some place else. This double stare is what gives the Lincoln photograph the elusive balance of publicness and privacy, of melancholy and public poise.

Senator Lane looks strangely like Lincoln, the same gauntness, the same chiseled face, the same unruly hair. In fact, he was an Abolitionist, an ardent supporter of Lincoln. But there is a deep difference. Senator Lane is a collection of public, conventional gestures, picked and defined by himself as a politician, of freedom, etc. There is no interiority to his gestures, to his pose. His deep stare off the camera, like everything else about him, is hollow, "masculine." Then we have Mrs. Lane's direct stare into the camera, pained, dwarfed but still surround-

ed with a halo of light.

The simultaneous experience by the observer of the two stares creates the disturbing power of this photograph. They constitute the double look of Lincoln's eyes. They represent to me the free gesture, the choice each of them makes beyond the arranged arrangement of the studio. A question still persists on my mind. Did Brady tell Senator Lane to look past the lens, and Mrs. Lane to look at the lens? I can not tell, but Brady's portraits are so ingrained in photography's idiosyncratic language as a medium that the subject (Senator and Mrs. Lane and their clothing and the furniture) is able to speak for itself regardless of Brady's intentions.

Brady's portraits, like many other 19th century American photographs, have an unconscious. In the case of this portrait, what does the unconscious say? That Senator Lane, the prominent abolitionist who fought for freedom, blacks' rights, had a slave in his house, like Jefferson, this woman in the photograph, his wife. Despite Senator Lane's self-defining gestures of romantic, manly independence, the aura he projects is domestic, completely self-unaware tyranny. The subject of this photo-

graph, for me, is the woman, the communication she creates with her stare with the viewer; it is about her subservient position as a woman, and the "natural" way the male dominated society, its conventions take this subservience for granted, *do not see it*.

I am sure neither Brady nor Senator Lane nor Mrs. Lane was aware of this effect of the portrait. But this is the beauty of a photograph, of the photographic language, its ability to record, trap and years later communicate to the observer the unacknowledged, unconscious, subversive, secret, unnameable thoughts, feelings, attitudes of a period, provided that photography is not seen as an "art" where the photographer, his point of view, is the key. In fact, a photograph gains resonance to the extent that its frame disappears, it loses its status as an art object, and it becomes a communication between subject and the observer. It becomes a democratic medium in which the common, the unrecognized, the downtrodden (anything non-mainstream, uncanonized) in the language can speak. The less intrusive the photographer the better.

I have tried until this point to point out some of

the key ingredients of photographic language, particularly in 19th century: 1) Light, and the impediments to the attempts to reproduce it. In fact, the failures, impurities, uncontrolled excesses in this attempt at reproduction often give the light substance. 2) Pose, as the subject's choice to look or not to look at the camera, and as the relationship among the animate and inanimate objects/subjects before the camera, the dialogue the pose creates with the observer.

In Le Gray's and Em. Pec.'s photographs, and in Brady's portraits, light and pose are fused into a clear, seamless unity. But in many others this fusion is implicit, "arbitrary," often one dimension dominating the other.

x. The Third Dimension:
What is a Photograph a Photograph Of?

There is a third dimension to a photograph, something not yet mentioned, its sine qua non, without which a photographic experience, language would not be possible. It is the feeling of "thereness" attached to each photograph. Underlying every photograph is the assumption that it is the photograph of "something." Its reproduction may be imperfect, distorting, that something may be pre-arranged; but, still, without that "thereness" photographic language is impossible.

It is this belief in the "thereness" attached to a photograph that spills photographic image into language. A photograph, specifically a 19th century one, contains subjects who are dead, gone or profoundly transformed. A photograph is imbued with the aura of mortality, death (the photographic glow is actually that aura), and the photographic dialogue between the subject and the observer is actually an attempt to recapture the dead, time, what is inexorably moving away from us.

(One of the earliest photographs, Talbot's "Vase with Medusa's Head, 1840," is the "white," glow-

ing image of an ordinary Grecian urn against a matte, "lavender" background. The image of the urn seems remote, hardly attainable, obtained not from the "world" but an elusive corner of the mind. This haunting image has none of the painterly, arty mannerisms of Talbot's other work. Talbot says that in "Medusa" he was trying to "capture" images seen in a Camera Obscura. That is the answer. A photograph is a recalcitrant, elusive image. The image in this photograph floats in a lavender space. This is space before language, the tabula rasa of photography. Talbot defines the structure of photographic language, creates its epistemology.)

"Mortality" and "time," the corollary of "thereness," are the energy source which starts the photographic dialogue. For instance, would the peculiar experiences of photographs such as "Senator and Mrs. James Henry Lane," "Abraham Lincoln" or "Broadside for Capture of Booth, Surratt, and Harold," etc. be possible if the observer did not believe in that "thereness." Otherwise, light and pose would lose their potency in the photographic dialogue.

May one argue that thereness must exist also in

a portrait? I do not think so. One can conceive, without a contradiction, that a portrait was painted completely out of the painter's mind. In fact, idealization, in various forms, is inherent to the language of Western art, from Greece to Byzantium to the Middle Ages, etc. On the other hand, thereness is embedded in the model of Camera Obscura. One cannot have a Camera Obscura image of nothing. Reflection and thereness are two faces of photographic totality.

Thereness is also integral to photography's democracy, what enables it to become a dialogue between subject and observer and pushes the photographer to the background. Would the gesture, pose, the choice to look at the camera or not have any significance without the assumption that these images in the photographs at one time "existed," that at a crucial moment "chose" to act in a certain way, that that specific action was independent from the photographer?

"Thereness," the belief that photography is "reproducing" the image that was already "there," is the underlying faith, dogma of photography, specifically American 19th century photography. This be-

lief is the god of photographic experience and language. If its existence were doubted, became suspect, the dialogue between the photographic subject and observer would disappear. The break will kill the image on the print.

There are essentially two ways to destroy the god of thereness in photographic language. The first is to eliminate the Camera Obscura model, that is to say, reflection, in the creation of photographic image. The second is to be able, technically, to "create" without a previous object a thereness so convincing that the belief in its independence is shattered. Both of them occur in the 20th century, the first, in Man Ray's rayographs, the second, by the computer's ability to create images which blur the distinction between fake and real (TV affability), copy and original (cloning), here and there (global village), imagined, inner and actual, produced (the stunning surreal sequence in a Goodyear commercial), make it increasingly tenuous. This conflict is at the heart of contemporary moral experience. In a Faustian exuberance, Special Effects say, "let's celebrate this disappearance" (Steven Spielberg). A counter movement (from

Man Ray's experiments to *Blade Runner*, book and movie) says that the distinction is vital; it devises strategies of alienation to de-obfuscate, to "make transparent" this difference, to create failures in the hostile and endless genera-tion of virtual images posturing as truths.

XI. Idiosyncratic Crises of Some 20th Century Photographs

A quality I observed in 19th century photographs, particularly French ones, was the existing photographic technique's inability the reproduce the "perfect" photographic image. This "insufficiency," "failure" of technique created some of the most potent spots, the glow, the distortion, the breakdown of focus, etc., mostly non-intentional, in 19th century photographs. By the beginning of 20th century photography had overcome most of those technical difficulties. The reproduced image is almost "perfectly" transparent. In some early 20th century photographs in this exhibit one senses the "missing" of that resistance of the photographic technique to reproduce the image. For instance, Heinrich Kühn's bichromate printing process and subsequent colored autochromes are new techniques to bring the "glow" to the light. What makes Kühn's photographs so powerful is their complete independence, despite of Kühn's theoretical writing on painting, from painting. Their independent pose dominates them, for instance, "The Artist's Umbrella, 1908." They are snapshots suffused with a

spiritual light.

Color is another dimension to create resistance in the early 20th century photographs. For instance, in Alexander Rodchenko's "Foxtrot, 1935," the one picture in the exhibition I would like to have on my wall, not only is color used, but the "negative" image is represented as the actual picture. This reversal turns the blank, white areas of the photograph (the behind of the woman in yellow dress, the white shadow/reflection on the wall, the "black" faces, the yellow/white hair of the man on the right, etc., etc.), in addition to the color sections added later, into fields of extreme power. I wonder now. Are these white folks or black folks dancing the foxtrot?

By the turn of the century, the pictures in the exhibit show the consciousness that shadow, that is to say, the shadow photographic subjects shed on each other, is an integral part of photographic language. These photographs are full of shadows and reflect the consciousness of the photographer that they are present and that's why he or she is taking them. But in many of them I have a sense that the photographer does not know what to do with them,

a sense of excess, as in Gyorgy Kepes's "Shadow of a Policeman, 1930" or László Moholy-Nagy's "Dolls on the Balcony, 1926." These photographs have two tendencies. Many move towards formal design, that is to say, to different styles of painting, such as George Seeley's "Winter Landscape, 1909," Eugene Druet's "The Clenched Hand, before 1898," Edward Steichen's "The Pond-Moonlight, 1904." I prefer others where the camera is more tranquil, meditative, often focusing on an emptiness, and lets the shadows, barely visible, start to speak among themselves, such as Eugène Atget's "Versailles, The Orangerie Staircase, 1901" and "Café, Avenue de la Grande-Armée, 1924-25"; or where the action is on the verge of being blurred, becoming itself a shadow, André Kertész's "Afternoon Constitutional of M. Prudhomme, Retired, 1926"; or where the movement from image to its shadow is relaxed and fluid, Alexander Rodchenko's "Asphalting a Street in Moscow, 1929" and "Morning Wash, 1930"; or, the most suggestive of all, where the distinction between positive and negative image is blurred, Man Ray's "Jacqueline Goddard, 1930."

One striking photograph by László Moholy-Nagy, "Decorating Work, Switzerland, 1925," demonstrates my reaction to the formalist use of shadows in a photograph. This is the photograph of the wall of a modern house with a man working at the top, four windows elegantly scattered, and telephone lines leaving their shadows on the wall. The white wall space, covering most of the photograph, is striking and draws the observer into itself. I observe the wonderful wall, the windows, the chips around the frame of one of them, the shadows the working man and a ledge on the right and the telephone lines leave on the wall, and the wonderful, wonderful empty space at the top left which the building can not cover.

But the photograph is so conscious and proud of its formal design, so unconscious of its mortality, that it leaves me disappointed; everything is so pointed towards the perfection of a form, that the photograph does not permit me to spill into language. Perhaps, what I am saying is that I love this photograph too much or that I am sad I don't love it, it does not permit me to love it enough. I feel baffled.

I suddenly notice something in the picture that I had noticed but not verbalized before. Three of the windows are bare, but a fourth on the left has decoration around itself, and what the worker is doing hanging before the top window is decorating it. He will go down then to each bare window and decorate it with the same flower design. ("Decorating Work" in the title does not refer to the formal aesthetic of the photograph but the worker's activity.) This realization transforms this photograph for me. First of all, it gives the worker a pose, independent from the photographer and his formalist aesthetic, and starts a dialogue between the worker and me (the observer) pushing the photographer aside. The worker will go to the next window and the next and decorate them all with flowers (The experience of the passage of time is sweetly mixed with a freedom of gesture). I also realize the not yet drawn pretty designs around the bare windows, already existent in one window and half in another, are part of the dialogue among windows, objects, in the photograph, one decorative design being the shadow, the reflection of another window, and that interaction between the worker and the window, as an on-go-

ing process, creates the interior dialogue, emanating from the photograph, which gives this photograph its mysterious power beyond the photographer's intentions and the observer's conscious understanding. In fact, the pretty decorations are somewhat in contradiction to the building's minimalist, Le Corbusier facade and the photographer's formalist Bauhaus aesthetics. That contradiction brings in the rich life of this photograph.

XII. Disruptions in the Photographic Image

I would like to end this essay with Man Ray, concentrating on one of his photographs, "Rayograph, 1923-28," because his work attacks, questions, potentially transforms the very basis on which the photographic aesthetic of the first hundred years is based, even of its most extreme examples.

In this photograph, which he calls photograms, May Ray goes to the beginning of photography, some of Talbot's experiments, to create his photographic image. He creates it by applying an object directly on a light sensitive material, a cameraless image, without the use of light "emanating" from the object (as in the Camera Obscura model). This is, in my view, the single most crucial act in twentieth century photography. Not only does it reset the terms of photographic discourse; but, potentially, it suggests innumerable possibilities beyond photography. One importance of this process is that the resultant image is unrecognizable and, to a significant extent, uncontrollable. Not only does this make the previous technical advances for perfect reproduction irrelevant, it transforms the principle

of "thereness" in the photographic language. It creates an image of pure shadows repeating, echoing each other around a white center. The power of these images is radically internalized, creating a new space both of or between the mind and the 19th century reproduced world. The striking light and dark shadows this image creates are so unique that the question, "what are they the photograph of, etc.," becomes almost unaskable. Almost, but not quite totally unaskable. The echo of the old world, as a photographic essence, remains in the dynamic shadows around a luminous white square center, a space connected to that in "Petit Mourmelon" and "Senator and Mrs. James Henry Lane." What "Rayogram" creates is a new tabula rasa for photography. What it casts overboard is the 19th century language emanating from the Camera Obscura thereness, reflection, "reproducing" an image existing in time. It does not eliminate thereness: is the luminous square not a trace of the mysterious object which was used for the photogram? It invites a new language. The link between photography and words persists. "Rayogram" is pregnant with words inviting a new language, requiring a new relation-

ship between itself and words, a more active partic-ipation from its viewer. What is this new language?

It is important to note that Man Ray does not use these dark and light shadows for formal, painterly effects. There is constant change, indeter-minacy, shadows of flowing liquids, explosions to-wards the frame. A language of framing, formality will not work. Though the images in "Rayogram" seem to move around a luminous center, open-end-ed indeterminacy seems to be of its essence. As the shadows inside "Rayogram" echo each other, pho-tograms have a tendency to repeat themselves. "Rayogram" is part of a series of other pho-tograms.

Tristan Tzara saw in Ray's images freedom; Robert Desnos saw "landscapes [of] chaos...more stupefying than that foreseen by any Bible." (p.352) Their words point to the surviving presence of two photographic essences in Ray's images: a) freedom, giving speech to the silenced, unspoken, what in 19th century framework I called democra-cy; b) "chaos," the innate instability of photograph-ic image, its subversive dimension. These two, I think, point to the nature of the new language, at

the turn of a new century, that Ray's shadow images present. Ray creates a counter-echo space in opposition to the space in our time. While our cultural space presses to blur the distinction between here and there, fake and real, etc., the counter space demystifies this process, obstructs, snips off the "natural" binds between the two. How do words penetrate and function in the pressure cooker of this counter space?

As shadows tend to echo, reproduce themselves in this space, so do words. Punning, often of a specific kind, becomes one dominant activity here. Words explode in uncontrollable, "chaotic" ways in all directions. While the myth of similarity, perfect fake (of *Jurassic Park* or a surrealist commercial) dominates the "virtual" space, mishearings, mistakes, bad taste dominate this verbal movement, progression through puns. While virtual space is an extension of 19th century reflection/reproduction as myth on a technological overdrive, the counter-echo space is based on difference. At the moment 19th century reflection starts losing its subversive transparency and becomes a tool of mainstream myth making, Ray removes the camera on which

the myth of similarity is based. It creates a counter space of difference, partly an interior space. Nevertheless, as photographic essence, a luminous blank square, the mystical, seductive sense of thereness, freed from similarity, remains, pulling words into itself.

Where is this new counter space? It is neither totally inside, psychological or hermetic, nor outside, where the principle of similarity dominates. It is a continuum, a verbal-visual field where the eye and the ear interpenetrate. Mishearings are aural echoes, atavars of "cameraless" shadows. Neither of the page, where words often progress over the edge of the page; nor quite of the ear since the ear needs the visual guidance of the placing and misspelling of words in space to determine their cadences and meanings. It is a space where the visual, also the silent, becomes heard, a newly defined democratic space. While in public space similarity dominates and words are handmaidens of aggressive images, in this space words are in the foreground. Often placed in ambiguous positions surrounded by white space, they force the reader to make choices. Their public shapes distorted, blurred but never quite a-

bandoned—they gain the potency of shadows.

In this last paragraph, I wish to remove my hat as a photography critic and reveal the driving purpose of this essay. It is an essay about language by a poet. During the last years I saw in photographic images suggestive and subversive possibilities which may be very useful in developing a poetry with a new relation to its reader and to the culture surrounding it, a poetry which reinvigorates words in a new way by relating them in and to space. The writing of this essay during two years bookends the writing of a poem series, *Io's Song*, in which I tried to apply, and vice versa, the ideas explored in this essay. I would like to end it with a poem from *Io's Song*, "Formula for Organic Substances":

 im ding words

 sin p l o p l o

 tax ex ding dong a trophy—alas!—entrophy

sunday in Claus trophobia

 Santa

 Pyhrric

 heart

 FINIS

PhotoTitles Index

The photographs referred to in the essay all appear in
the Metropolitan Museum exhibition catalogue, *The
Waking Dream: Photography's First Century: Selections
from Gilman Paper Company Collection* (New York: The
Metropolitan Museum of Art. 1993). Photographs are
classified under each photographer's name in the order in
which they are referred to in the essay. The first number
after each title refers to the photograph's catalogue num-
ber, the second number, in italics, if any, refers to its plate
number:

Gustave Le Gray, "Group near the Mill at Petit-Mourmelon, 1857" (66)

"Cavalry Maneuvers, Camp de Chalons, 1857" (65, *58*)

"Mediterranean Sea at Sète" (64, *64*)

David Octavius Hill and Robert Adamson, "Cottage Door, 1843" (12)

Gyorgy Kepes, "Shadow of a Policeman, 1930" (234, *195*)

André Kertész, "Afternoon Constitutional of M. Prud-homme, Retired, 1926" (243, *167*)

Heinrich Kühn, "The Artist's Umbrella, 1908" (177, *152*)

John Dillwyn Llewelyn, "Thereza, ca. 1853" (15, *16*)

Robert Macpherson, "The Theater of Marcellus, from the Piazza Montanara, 1858" (82, *74*)

William Marsh, "Abraham Lincoln, 1860" (129, *104*)

László Moholy-Nagy, "Dolls on the Balcony, 1926" (231, *177*)

"Decorating Work, Switzerland, 1925" (230, *163*)

John Murray, "The Taj Mahal from the Bank of the River, Agra, 1858" (102, *80*)

Em. Pec., "Chartres, 1850-52" (50, *54*)

"Bourges, 1850-2" (49)

"Jacqueline Goddard, 1930" (218, *173*)

Man Ray, "Rayograph, 1923-28" (217, *181*)

Henri-Victor Regnault, "Gardens of Saint-Cloud" (53, *49*)

Henry Rhorer, "View of Cincinnati, 1865-66" (146, *98*)

Alexander Rodchenko, "Foxtrot, 1935" (228, *175*)

GREEN INTEGER
Pataphysics and Pedantry

Douglas Messerli, *Publisher*

Essays, Manifestos, Statements, Speeches, Maxims,
Epistles, Diaristic Notes, Narratives, Natural Histories,
Poems, Plays, Performances, Ramblings, Revelations
and all such ephemera as may appear necessary
to bring society into a slight tremolo of confusion
and fright at least.

*

Green Integer Books

Green Integer EL-E-PHANT Books (6 x 9 format)